A Photojournalist
Kabul to Beirut

— A Screenplay —

BY

HAAS HASSIB MROUE

authorHOUSE®

AuthorHouse™ UK
1663 Liberty Drive
Bloomington, IN 47403 USA
www.authorhouse.co.uk
Phone: 0800.197.4150

Published by AuthorHouse 04/16/2015

ISBN: 978-1-4969-7931-5 (sc)

Print information available on the last page.

We [the children] lived a war with no name
and escaped. We now belong to a culture
that has no name.

<div align="right">Haas Mroue</div>

Other Books by Haas Mroue

Beirut Seizures
The Passport Stamper
Cucumber and Mint
8 Short Stories
Amsterdam Day by Day
Memorable Walks in Paris

About the Author

Haas Mroue (1965 - 2007)

Haas Mroue brings us another inspiring story based on his traumatic experiences of the Lebanese Civil War. His first book, a collection of poems entitled *Beirut Seizures,* won acclaim among creative writing students and communities. The second book, *8 Short Stories,* is a strong voice that examines the dark faces of war.

Haas was born and raised in Beirut. He fled the war with his mother in 1975 and lived in several countries before he laid his roots in the United States of America. Haas graduated from the University of California–Los Angeles (UCLA) School of Theater, Film and Television and completed the master's programme from the University of Colorado Boulder. For the last ten years of his life he was living and writing in Port Townsend, an idyllic city in Jefferson County in Washington.

Haas wrote *A Photojournalist, Kabul to Beirut* before he died suddenly of a heart attack while on a visit to Beirut. Although written as a screenplay for film production, it flows smoothly as a story.

See www.haasmroue.net

About the Book

In your hands is a precious book, *A Photojournalist, Kabul to Beirut*, by Haas Mroue. It is one of the very few collected writings in English about the perils of the civil war in Lebanon that took place from 1975 to 1991. As a child living in Beirut, Haas experienced the struggle of everyday life and the loss that comes with war. Later, he wrote, "We lived a war that has no name and escaped. Now we live a culture that has no name." In simple words, he wove together a smooth tale of events that invites us, in a time of conflict, to look deep into our conscience and find our most worthwhile nature as humans.

A Photojournalist, Kabul to Beirut will interest all those who are or have been affected by war. There are those living in war zones, such as in the Arab Spring countries. Syria is presently at the forefront of considerations of such a dilemma. Then, there are those making a living out of war or those who are trying to prevent a war by peaceful measures. Most importantly, *A Photojournalist, Kabul to Beirut*, will interest the reader who is seeking the ultimate truth about losing and living.

The manuscript was sent from heaven. We don't know exactly when Haas wrote it but probably several years before he died in 2007. I found it among his personal effects when they were shipped from his home in the United States of America to my address in England. It was typed and bound and – apart from being untitled – was ready for publication. I kept the manuscript exactly as Haas had written it with two additions: I chose a title for the manuscript and commissioned AuthorHouse to provide five illustrations.

Najwa Mounla

England, Nov 2014

Najwa Mounla is Haas's mother, and since he died in 2007, she has been the editor of his books. She is the founder and trustee member of the Haas Mroue Memorial Fund for Creative Writing.

To all the children who lose their childhood in a civil war
and to their parents who cannot explain.

**A Photojournalist,
Kabul to Beirut**

A Screenplay

By Haas Hassib Mroue

EXT. A FIELD IN AFGHANISTAN - DAY

We hear the sounds of bombs exploding and shells crashing as we see a number of tanks approaching a village.

EXT. VILLAGE STREETS - DAY

We continue to hear the rumbling of tanks getting closer. We see OLGA (42), an American photojournalist. She is a thin, quick-paced woman. She runs from street to street taking photographs. She is guided by TWO AFGHANI FIGHTERS.

EXT. HOUSE - DAY

Olga, protected by the two fighters, takes photographs from the balcony of a two-storey house that looks down on to a narrow street.

EXT. NARROW STREET - DAY

A WOMAN is running down the street. She is carrying a baby in her arms. The tanks are now behind her. She is shot from the back.

As she is shot the action is replaced by:

BLACK AND WHITE STILLS.

In the series of photographs we see the woman collapsing on the ground, the baby cradled tight in her arms. We hear the baby crying painfully.

BEGIN CREDITS.

Return to LIVE ACTION:

EXT. NARROW STREET - DAY

Olga runs closer to the woman. She hides in a doorway and takes more photographs. The woman lies in the middle of the narrow street. The tanks do not stop, and they run over her and her baby. Olga continues taking photographs until her two guides motion for her to leave. We continue to hear the sound of the baby crying.

EXT. TRAINING FIELD - DUSK

We hear a musical instrument, almost like a guitar, being played, and we see Olga and a number of the 'mujahideen'

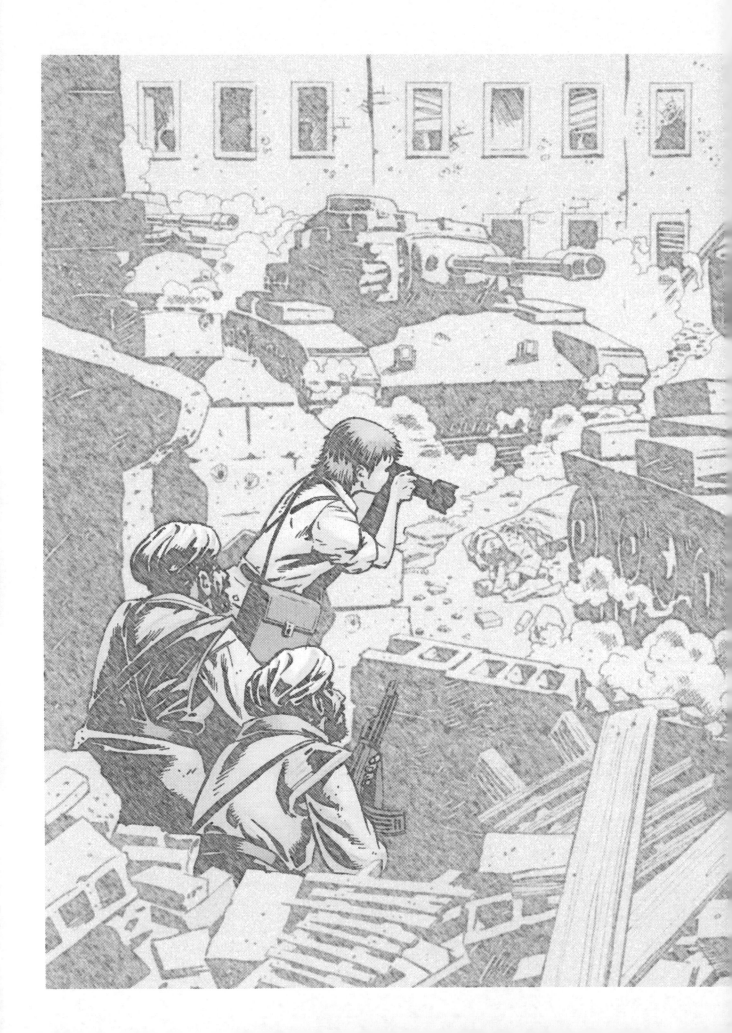

fighters sitting in a circle around a fire. A young fighter
playing the instrument begins to sing softly.

> AFGHANI FIGHTER #1
> Olga, why don't you stay here
> tomorrow and take photographs
> when we try to recapture the
> village that we lost today?

> OLGA
> I would really love to, Moussa,
> but I have to get back to Paris
> tomorrow. I took great
> photographs today.

> AFGHANI FIGHTER #2
> Will you be back soon?

> OLGA
> I hope so. If my boss likes the
> photos.

> AFGHANI FIGHTER #1
> What will you do with the
> photos?

> OLGA
> First, my boss has to decide
> which ones he likes best. Then
> they are wired around the world.
> The world needs to know what is
> happening here.

> AFGHANI FIGHTER #2
> I think no one cares about us

> OLGA
> We'll have to make them care.
> What I saw today is
> unacceptable. This can't happen
> in the eighties in a civilized
> world.

> AFGHANI FIGHTER #1
> Try to come back soon. We liked
> showing you around today.

> OLGA
> I'll try.

> AFGHANI FIGHTER #2
> Come on, let's show you how we
> dance.

 OLGA
 Oh, I am so tired. I have to get
 back to the city to catch my
 flight.

 AFGHANI FIGHTER #2
 Just one dance.

 OLGA
 A quick dance.

The two fighters show Olga how they dance, making her join
in with them. The music is louder now, and all the fighters
get up, and they begin to dance.

EXT. FIELD - NIGHT

Olga is in a jeep with all of her equipment. The fighters
all wave to her as the jeep begins to move. We can still
hear the music, and we see some of the fighters still
dancing as the jeep disappears.

END CREDITS.

EXT. PARIS CHARLES DE GAULLE AIRPORT - DAY

Plane lands.

EXT. AIRPORT TAXI RANK - DAY

Olga is with a family of immigrants. She holds the hand of
the youngest child as they carry their many bags and
bundles. She waves down a taxi.

 OLGA
 Driver, take them to this
 address. Here's 200 francs. That
 should be more than enough.
 Don't take any money from them.

 TAXI DRIVER
 Thank you, Madame.

 OLGA
 (to the family)
 I hope you find your relatives.
 Don't worry, soon you'll get
 used to the new life.

She kisses the children and waves goodbye as the taxi leaves. Olga gets in a car marked 'International Press Service'.

INT. PRESS CAR - DAY

Olga is comfortably sprawled on the backseat. Her regular driver BERNARD (65) is at the wheel.

> BERNARD
> How was your trip, Mademoiselle Olga?

> OLGA
> Excellent, Bernard. I'm so tired, though. I haven't slept in three days.

> BERNARD
> Do you want me to take you home?

> OLGA
> No, I need to go to the office first. Anything new?

> BERNARD
> Everybody is talking about the awards next month. Of course Francois thinks he's getting all of them. He's so proud of that one photo he took in Ethiopia.

> OLGA
> Francois always thinks he's the best.

> BERNARD
> Maybe it's because of the new wife of his. She's young. A blonde. He thinks he's the greatest man in the world.

> OLGA
> Maybe.

EXT. PRESS CAR - DAY

The car weaves its way through the outskirts of Paris — so full of life and traffic.

EXT. PRESS OFFICE BUILDING - DAY

The car draws up. Olga gets out.

> OLGA
> I won't be long, Bernard.

Olga heads into the office building.

INT. OFFICE - DAY

As soon as Olga walks in everyone gets up to greet her, including the secretaries and the janitor. Her associate and best friend, CLAUDE, hugs her. FRANCOIS looks on.

> CLAUDE
> Olga. Tell us — tell us — did you get what you wanted?

> OLGA
> Yes. A whole day with the mujahideen. They even asked me to stay on for another day.

> CLAUDE
> Where are the films?

Olga hands her a few rolls of films.

> CLAUDE
> I'll have them developed right away.

> FRANCOIS
> So, Olga, you took good photos?

We hear giggles as if the crowd senses the competition between the two photojournalists, Francois and Olga.

> OLGA
> Yes, very good. Thank you for your concern, Francois.

> CLAUDE
> (whispering)
> What a slimebag.

> OLGA
> I'm very tired, Claude.

> CLAUDE
> Let's go into my office.

INT. CLAUDE'S OFFICE - DAY

Olga flops down onto Claude's chair.

> OLGA
> Where's the boss?

> CLAUDE
> Oh, he went out to one of his
> long lunches. So you had a good
> trip?

> OLGA
> Yeah, great. Some sights were
> extra-gruesome, though.

> CLAUDE
> Captured?

> OLGA
> You're holding them.

> CLAUDE
> Oh, I need to get them to the
> darkroom.

> OLGA
> I'm leaving, I need to get some
> sleep.

Olga gets up to leave.

> CLAUDE
> Oh, Luc called to ask me when
> you're coming back.

> OLGA
> So he knows I'm coming tonight?

> CLAUDE
> Yes.

> OLGA
> I missed him.

Olga leans on the door.

> CLAUDE
> It's getting serious, huh?

> OLGA
> Yeah. He's getting a divorce.

 CLAUDE
 You want to marry him?

 OLGA
 Maybe. I'd like to have a child
 and a stable life for a while.
 You know, I'm getting tired more
 easily. We're getting older,
 Claude.

 CLAUDE
 Don't be ridiculous. Go get some
 sleep; you'll feel better, and
 stop reminding us of our age.
 Lunch tomorrow?

 OLGA
 Yep. See you. Oh, by the way,
 how's the family?

 CLAUDE
 Fine. Jerome always asks about
 you. And Marianne cries. Take
 care, Olga.

Olga leaves.

EXT. APARTMENT BUILDING - DAY

Olga gets out of the car, and Bernard hands her the bags.

 OLGA
 Thank you, Bernard. Have a good
 evening.

 BERNARD
 Bye, Miss Olga.

INT. APARTMENT BUILDING - DAY

The CONCIERGE, a big woman, comes out of her apartment to
greet Olga.

 CONCIERGE
 Miss Olga. How was your trip?

 OLGA
 Very good, thank you.

 CONCIERGE
 You took good photos this time,
 too?

 OLGA
 I hope so. Is there any mail for
 me?

 CONCIERGE
 A lot.

The concierge hands Olga the mail.

 OLGA
 Have a good evening, Madame
 Pinot.

INT. OLGA'S APARTMENT - DAY

Olga lets herself in, studying her mail.

It's a bright open plan apartment with a kitchen and living
room area, with a bedroom leading off. There is a knock on
the front door. A young, frail woman enters. She is CLAIRE,
Olga's next-door neighbour.

 OLGA
 Come in, Claire.

 CLAIRE
 I've been waiting for you.

 OLGA
 What's wrong? You look pale.

 CLAIRE
 He's been beating me again.

 OLGA
 Why?

 CLAIRE
 I don't know. He comes home in
 the evening, and if he doesn't
 like the food I cook he gets
 angry and hits me.

 OLGA
 Why do you stay with him,
 Claire?

 CLAIRE
 I'm pregnant.

> OLGA
> Oh. Can't you go to your
> parents' house and have the baby
> in peace?

> CLAIRE
> I don't want to have his baby.

> OLGA
> What are you going to do?

> CLAIRE
> I want an abortion. Will you
> help me, Olga?

> OLGA
> Claire, you have to think very
> carefully about this. I'm forty-
> two years old, and I wish I had
> had a child when I was still
> young. You don't want to do
> something you may regret later
> on.

> CLAIRE
> But you will help me if I decide
> to have an abortion?

> OLGA
> Of course I will.

> CLAIRE
> I have to get back home.

> OLGA
> Won't you have some wine with
> me?

> CLAIRE
> I can't. He'll be home any
> minute, and he wants me to be
> home when he comes back.

Claire leaves, and then she pops her head back in.

> CLAIRE
> I forgot to ask you: How was
> your trip?

> OLGA
> Good. Great.

> CLAIRE
> See you later, Olga.

Olga opens a bottle of wine and searches in her fridge for something to eat.

INT. DARKROOM - DAY

Claude is looking at the black and white photographs of the woman in Afghanistan.

> CLAUDE
> These are amazing.

INT. THE BOSS'S OFFICE - DAY

Claude shows the photographs to the BOSS.

> BOSS
> I want them wired to New York
> immediately. At least one should
> be in *The New York Times*
> tomorrow. I'll call Olga and
> congratulate her. She's been
> doing great.

> CLAUDE
> Yes, she has. I better get on
> the line with New York.

Claude begins to leave.

> BOSS
> Claude.

> CLAUDE
> Yes?

> BOSS
> How does she do it?

> CLAUDE
> Do what?

> BOSS
> How does she manage to get so
> close and always get the best
> photograph?

> CLAUDE
> I think it's her cool. Most
> photographers are aggressive and
> pushy. She gets her way through
> her charm, quietly. Olga's a
> gem.

 BOSS
 Thank god we got her before UPI
 did.

INT. OLGA'S APARTMENT - NIGHT

Olga is sitting in a bathrobe talking on the phone, her
hair is still wet. She smiles her big smile.

 OLGA
 Is that what he said? Thank God
 we got her before UPI? Yeah,
 that is a big compliment coming
 from him.

The doorbell rings.

 OLGA
 Claude, I gotta go. Luc's here.
 See you tomorrow.

Olga opens the door to reveal LUC, a tall, handsome man,
carrying a bouquet of flowers. They smile at each other and
embrace. Luc carries Olga into:

THE BEDROOM

Luc kisses Olga slowly, taking off her bathrobe. He
undresses, kissing Olga passionately all the time. Olga
moans.

INT. OLGA'S APARTMENT - LATER

Olga is in the kitchen. She is naked. She arranges some
cheese and grapes on a plate. She carries it into:

THE BEDROOM

Luc is dressing.

 OLGA
 I can make you some dinner if
 you want.

 LUC
 I really have to go.

Olga puts her bathrobe on.

 OLGA
 I don't know why I ever accepted
 to go out with you.

 LUC
What do you mean?

 OLGA
You're married.

 LUC
I'm getting a divorce.

 OLGA
When?

 LUC
Soon.

 OLGA
Why not now?

 LUC
The lawyer will advise me of the
best time.

 OLGA
I'm so tired. Something is
missing in my life.

 LUC
What do you want from life,
Olga? You have everything.

 OLGA
I want you to love me full time.
I want a child. I want a stable
life for a change. I'd like to
know how it feels to have a
house and a husband and a child.
Claude is happy; she gave up
travelling to have a family. Now
she's stuck at the office all
the time, but she knows that at
night she's going home to her
kids and her husband.

 LUC
Soon, Olga, that's all I can say
right now.

 OLGA
I love you, Luc.

 LUC
I love you too.

They embrace.

 LUC
 I gotta go.

Olga watches him as he finishes dressing.

 OLGA
 Let's go away for a weekend
 somewhere. I feel like going to
 the ocean. You know that's the
 only thing I don't like about
 Paris; it's a long way to the
 sea.

 LUC
 I'll call you and let you know
 when I can get away, okay?

 OLGA
 Okay.

INT. OLGA'S FRONT DOOR - NIGHT

They embrace one more time, and then Luc leaves.

INT. OLGA'S KITCHEN - NIGHT

The stereo is on. The French singer Barbara (Monique Andrée
Serf) is singing "MY MOST BEAUTIFUL LOVE STORY". Olga
nibbles on grapes and cheese.

EXT. CAFE TROTTOIRE - DAY

Olga and Claude are having lunch. The WAITER takes their
order.

 OLGA
 I'll have the brie with grapes.

 CLAUDE
 Is that all you're having?

 OLGA
 Uh-huh.

 CLAUDE
 I'm having the Greek salad.

 WAITER
 Very well, Mesdames. Some wine
 perhaps?

 OLGA
How about a bottle of Chablis?

 WAITER
Very well.

 CLAUDE
So he's really getting a
divorce?

 OLGA
That's what he says.

 CLAUDE
When?

 OLGA
I don't know. But I stopped
taking the pill. I want to be
ready to have a child when we
start living together.

 CLAUDE
Does he know?

 OLGA
No. What I do with my body is my
business.

 CLAUDE
Oh, I didn't tell you. Francois
and the boss went out to lunch
yesterday. Everyone at the
office is talking.

 OLGA
The boss never goes out to lunch
with any of his staff.

 CLAUDE
Maybe the boss likes Francois's
young blonde wife, huh?

 OLGA
Possible.

 CLAUDE
You know, he really loved those
photos of yours. I think you'll
get the prize next month.

 OLGA
I'm trying not to think about
it, but I am excited.

 CLAUDE
 So much is happening next month:
 We're moving to the country
 finally; I'll stop working full-
 time; summer begins. Do you want
 to come up next weekend and help
 us paint the house?

 OLGA
 I would love to, but Luc and I
 are going to Deauville.

 CLAUDE
 Oh, lovers weekend. Well give me
 a call Sunday night with the
 highlights.

EXT. COUNTRY ROAD - DAY

We see a car speeding past cows grazing and beautiful
fields filled with blooming flowers.

INT. CAR - DAY

Luc is driving. Olga has her head halfway out of the
window.

 OLGA
 It's so beautiful. I love
 everything in the spring. It's
 out of the world.

She turns to Luc.

 OLGA
 I love you in the spring.

She kisses him.

 OLGA
 I'm still mad at you.

 LUC
 Why?

 OLGA
 You know why. You tell me we're
 going away for the weekend, and
 then you show up, and it turns
 out we're going to spend
 Saturday by the ocean.

 LUC
 I'm spending a whole day with
 you, Olga.

 OLGA
 You make it sound like a
 sacrifice on your part.

 LUC
 What's bothering you?

 OLGA
 What's bothering me? I psyched
 myself for a weekend away from
 Paris. I turned down other plans
 with my friends to be with you.
 Now I'll be stuck Sunday by
 myself.

 LUC
 You know, I never know if you're
 really angry. You always speak
 so calmly.

 OLGA
 A weekend means at least two
 days and one night. Are you sure
 you went to school, Luc?

 LUC
 Can we change the subject? Let's
 enjoy the time we have together.

 OLGA
 Okay, I'll forgive you this
 time. You love me, Luc?

 LUC
 I love you Olga.

EXT. VILLAGE STREETS - DAY

Luc and Olga are walking hand in hand in the tiny streets
of the village by the sea. On the corner of the street,
Olga sees a woman selling some big earrings, and Luc buys a
pair for her.

EXT. CLIFF TOP - DAY

Luc and Olga are having lunch on the grass at the top of a
cliff overlooking the sea.

 OLGA
 It's so beautiful.

 LUC
 It is.

 OLGA
 It is out of this world.

EXT. APARTMENT BUILDING - NIGHT

Luc's car stops, and Olga gets out.

 OLGA
 When you get home will you do me
 a favour?

 LUC
 What?

 OLGA
 Look up the word 'weekend' in
 your dictionary.

Luc drives off, laughing.

INT. OLGA'S APARTMENT - NIGHT

Olga is bored and restless. She switches channels on her
TV, and then she turns it off. She stands in front of the
mirror, checks her face and studies her body. She opens a
bottle of wine. The doorbell rings.

 CLAIRE
 Hi, Olga.

 OLGA
 Claire, nice to see you. Come on
 in.

 CLAIRE
 What are you doing alone on
 Saturday night? I thought I
 wouldn't find you.

 OLGA
 Married men.

> CLAIRE
> Oh. I've decided to keep the
> baby. He's been treating me
> better since I threatened to
> leave.

> OLGA
> It'll be great having a baby
> next door; I can babysit on
> Saturday nights.

> CLAIRE
> Maybe you'll have your own baby
> soon.

> OLGA
> I'm working on it.

Claire looks confused. Olga smiles.

> OLGA
> Have some wine. Would you like
> some cheese?

> CLAIRE
> No thanks. I have to go; he
> doesn't like me coming to see
> you.

> OLGA
> Why?

> CLAIRE
> I don't really know. I think he
> feels you are very independent,
> and he's scared some of it will
> rub off on me.

> OLGA
> He's not going to prevent you
> from seeing your friends.

> CLAIRE
> I don't want to make him mad
> now. I should go. Good night,
> Olga.

> OLGA
> Good night.

Olga sips her wine and then opens the windows in her
apartment, letting the breeze in. She switches on the
stereo and plays the song "MY CHILDHOOD" by Barbara. She
picks up a photograph album and flips through it. We see

the photos she is looking at from her childhood. We
recognize Olga because the girl in every photo is very
thin, just like Olga is now.

EXT. OLD HOTEL - NIGHT

Olga and Luc, Claude and her husband, JEAN-PIERRE, and a
crowd of other very fancily dressed people walk into the
hotel.

INT. HOTEL BALLROOM - NIGHT

Olga sits at a table next to Luc. Claude and Jean-Pierre
sit opposite them.

> CLAUDE
> Look at Francois. He thinks he's
> getting an award.

> OLGA
> Maybe he will.

> CLAUDE
> You will, Olga. Quit thinking
> negative.

> OLGA
> (whispering)
> I'm glad you came, Luc. If I
> have to give a speech I'd like
> to know you're here.

Luc kisses her. Claude and Jean-Pierre smile.

A man whom we recognize as the boss stands on the podium,
facing all of the tables.

> BOSS
> Ladies and gentlemen, may I have
> your attention please? I will
> not bore you with long speeches;
> we have many awards to give
> tonight. I would like to make a
> comment about the first award
> category: photojournalism.
> It is one of the toughest areas
> of photography, as it demands so
> much from both the mind and the
> body.

It involves sacrificing a lot to
convey the truth. It means
rushing to a location whenever
you are asked, never complaining
about the heat, the bombs, the
smell of death or hunger. Very
few people are able to make a
lifetime commitment to this
profession. Our first winner
tonight has shown incredible
will to attain the truth. Last
month this person went to
Afghanistan and was able to take
a few photos that shook the
world. This is what the aim of
every photojournalist should be:
to make a change in this world
and not in his or her portfolio.
Ladies and gentlemen, this
year's winner of the Annual
Photojournalism Award is Olga La
Rochelle.

Everyone begins to applaud and looks in the direction of
Olga who shyly gets up and makes her way to the podium. The
boss whispers something in her ear.

 OLGA
Thank you, thank you. I'm not
used to this much attention. I-
I'm not very good at speeches.
Mr Carton has helped me out; he
told me to talk about the way I
work. I will answer truthfully —
I'm not sure myself. Once I'm
with my camera in a certain
situation — war, for example — I
forget who I am and what I am,
and all my energy goes into
getting that photograph. I lose
my sense of time, and I forget
to be afraid or hot or cold or
hungry. And when it's all over I
look at the photograph and
wonder if it was someone else
who took it. However I do it I
love it, and I love you all for
honouring me tonight. Thank you
all very much.

More applause. Claude stands up, clapping loudly, and then
Jean-Pierre and Luc stand, and then the rest of the people
stand. Olga wipes a few tears as she walks back to her
table. Claude hugs her.

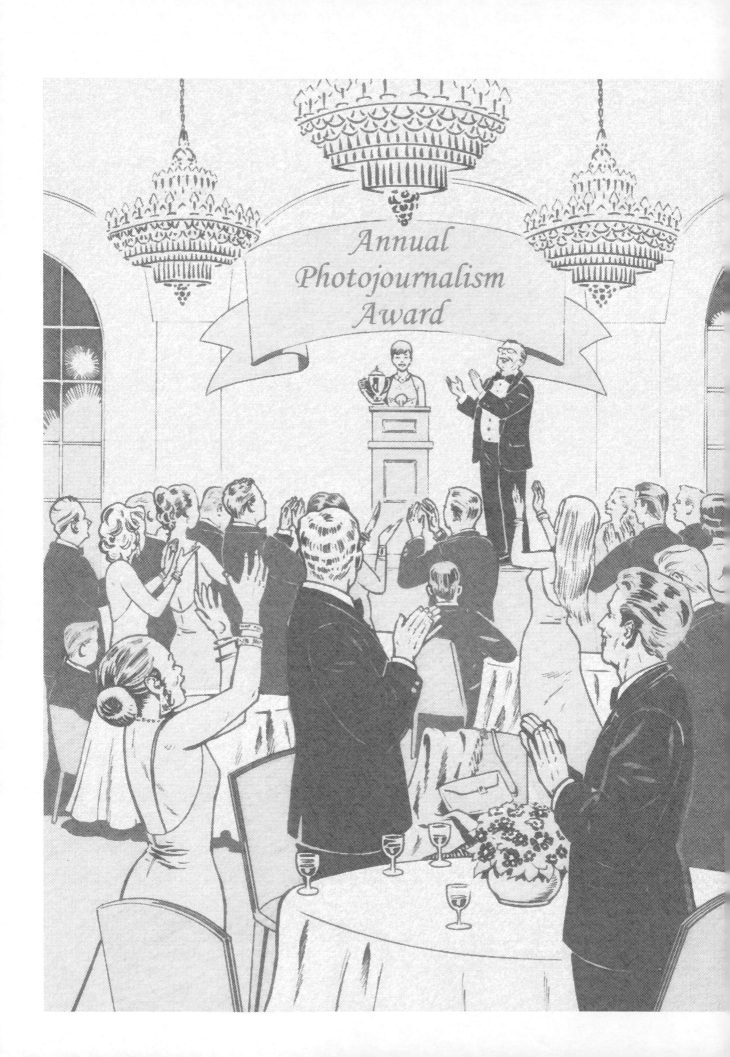

 OLGA
 Let's powder our noses.

 CLAUDE
 See you later, guys.

 BOSS
 Our second category of awards
 goes to the travel photographer…

INT. BATHROOM - NIGHT

Olga leans on the sink to catch her breath.

 OLGA
 My heart is beating so fast.

 CLAUDE
 Your speech was great.

 OLGA
 I've never felt like this in my
 life. It feels good, Claude.

 CLAUDE
 Francois must be fuming.

 OLGA
 I told you he wouldn't win.

 CLAUDE
 You told me? Huh.

They laugh and adjust their hair. Olga studies her stomach
in the mirror.

 OLGA
 Do you see something?

 CLAUDE
 No. Should I?

 OLGA
 I think so.

 CLAUDE
 No? You don't mean …?

 OLGA
 Uh-huh.

 CLAUDE
 Aahh. Aahh.

 OLGA
 I'm not sure yet. I'll get the
 urine result tomorrow.

 CLAUDE
 Does Luc know?

 OLGA
 No. I'll tell him tomorrow when
 I'm sure. Come on, let's go get
 drunk.

INT. BALLROOM - NIGHT

Claude and Olga sit down at the table. Olga kisses Luc and
stares at him.

 LUC
 What's the matter?

 OLGA
 I'm looking at the colour of
 your eyes.

 LUC
 You've never noticed before?

 OLGA
 I'm just checking.

 LUC
 Checking what?

 OLGA
 To make sure they're light
 green.

 LUC
 Why?

 OLGA
 Nothing. I love you. That's why.

EXT. STREET - NIGHT

Olga, Luc, Claude and Jean-Pierre walk down the street.
They've obviously had too much to drink. They talk in loud
voices, and they don't walk straight.

 OLGA
 I love summer.

 CLAUDE
 It's still spring. Summer is
 next week.

 JEAN-PIERRE
 What difference is it?

 CLAUDE
 Paris is nicer in the spring.

 OLGA
 I always love Paris.

Olga begins to sing softly.

 OLGA
 I love Paris in the summer.
 I love Paris in the spring.

 LUC
 I love Paris in the winter when
 it sizzles.

 CLAUDE
 I love Paris in the summer when
 it sizzles. I prefer the spring.
 You guys have to come to visit
 us when we move to the country.
 I can't wait until next week.

 OLGA
 I'd love to. But I still love
 Paris in the summer.

 LUC
 When it sizzles.

Luc carries Olga and rocks her in his arms.

 OLGA
 Let me down. Luc, let me down.

EXT. OLGA'S APARTMENT - NIGHT

Luc and Olga are on the doorstep.

 OLGA
 Your wife is going to be mad;
 you're very late.

 LUC
 It was worth it. You're the
 greatest, Olga.

 OLGA
 If I'm the greatest then why am
 I spending the night alone?

 LUC
 The lawyer told me not to spend
 the night out; it'll just
 complicate the divorce
 procedures.

 OLGA
 What does a lawyer know about a
 woman's needs? Okay, okay, I'll
 see you tomorrow.

 LUC
 Sleep well.

 OLGA
 Sure, sure.

EXT. PARK - DAY

Olga walks, smiling at all the women pushing baby
carriages.

INT. WAITING ROOM - DAY

Olga sits between two pregnant women, their stomachs
bulging in front of them.

 RECEPTIONIST
 Mrs La Rochelle.

 OLGA
 It's Miss. Yes?

 RECEPTIONIST
 Doctor Marc can see you now.

INT. DOCTOR MARC'S OFFICE - DAY

DOCTOR MARC, an older man, smiles at Olga.

 DOCTOR MARC
 Good morning, Olga.

 OLGA
Hello. Did you get the results?

 DOCTOR MARC
Yes. I'm afraid you are
pregnant.

 OLGA
Afraid? That's great.

 DOCTOR MARC
I still do abortions you know.

 OLGA
Doctor Marc, I don't think you
understand. I'm keeping this
baby.

 DOCTOR MARC
But last time you insisted on
having an abortion immediately.

 OLGA
Last time, I was thirty-four
years old; I felt I had a
lifetime ahead of me. Now I know
life moves quicker than anything
around us.

 DOCTOR MARC
But I thought your work demands
a lot?

 OLGA
It does. But this is my last
chance to have a child, and I'm
hanging on to it.

 DOCTOR MARC
Well, I hope you're doing the
right thing.

 OLGA
I am. Thank you for your
concern.

Olga gets up to leave.

 DOCTOR MARC
Goodbye, Olga. Come see me in
four weeks; I need to give you
some iron and other supplements.

27

 OLGA
 Okay, thanks.

EXT. PARK - DAY

Olga sits down on a bench, clutching her stomach, a half-
smile on her face. A few tears trickle down her cheek; she
is crying from happiness.

INT. OLGA'S APARTMENT - NIGHT

Olga prepares dinner in the kitchen. She has the table set
very elegantly with flowers and expensive china. The
doorbell rings. Luc comes in.

 LUC
 Hi. Kiss?

 OLGA
 No.

 LUC
 What's the matter now?

 OLGA
 Just wait a minute.

She hands him the champagne bottle.

 OLGA
 Here, open this.

 LUC
 What's the occasion?

 OLGA
 Quit talking, and open it.

He opens it, Olga watching him and smiling.

 LUC
 Where are the glasses?

 OLGA
 Here, here.

Glasses filled, they stand facing each other. Olga raises
her glass.

 OLGA
 To our baby.

 LUC
No?

Olga nods.

 LUC
No.

 OLGA
Yes. It's yes, Luc. In seven and
a half months — about 24
January.

 LUC
Olga, what about the pills?

 OLGA
What about them?

 LUC
Weren't you taking birth control
pills?

 OLGA
I stopped taking them.

 LUC
Why?

 OLGA
Because I wanted to be ready to
have a child when you finalized
your divorce. It happened a few
months early, so what?

 LUC
I haven't even started the
divorce procedures yet.

 OLGA
What?

 LUC
You heard me, Olga.

 OLGA
I heard you, I heard you. Then
it was all lies. Was it all
lies? Luc answer me.

LUC

No. The lawyer advised me to
wait until we can prove that my
wife is seeing another man. If
not, I'll have to give up half
my assets.

OLGA

So I'm not worth half of what
you own, huh?

LUC

It's not only that.

OLGA

I'm getting angry, Luc. Would
you make yourself clear, please?

LUC

Olga, even if I do get a
divorce, it won't be for another
year or so, and then I'd want
some time off by myself away
from wives and kids and full-
time work. So even then I
wouldn't be able to take care of
you and a baby.

OLGA

So all our plans — everything we
talked about — were lies?

LUC

You were the one who planned,
Olga. I never lied to you. I am
getting a divorce; it's just
slow. I do want to be with you,
but maybe not all the time at
first. I can't jump from
marriage to marriage.

OLGA

So your child will be
fatherless.

LUC

You don't have to have it.

OLGA

It's my last chance, Luc. Don't
you understand? I'm forty-two
years old, damn it. I'm having
this baby. Are you going to be
around or not?

 LUC
 I can't make any promises, Olga.

 OLGA
 Could you please leave now? I
 need to be alone.

Luc kisses her on the cheek. She turns away.

 LUC
 I'll call you.

 OLGA
 No. Don't. Don't call me.

Luc leaves. Olga stares out at the city, drinking the
champagne. She clutches her stomach.

 OLGA
 Well, I guess it's going to be
 just you and I kiddo.

EXT. SMALL TRAIN STATION - DAY

Claude waits as a train pulls in, and Olga gets out.

 CLAUDE
 Olga.

They hug.

 OLGA
 It's good to be out of Paris for
 a while.

 CLAUDE
 So he couldn't handle it, huh?

 OLGA
 No, I haven't seen Luc for a
 week. I have no intention to
 call him, either.

 CLAUDE
 Well, now you're in the country.
 Let's forget the city and its
 problems and enjoy the fresh
 air.

They get in the car.

EXT. COUNTRY ROAD - DAY

Claude's car goes through beautiful green pastures. Olga
has her head halfway out of the window.

INT. CAR - DAY

Olga calls back in to Claude over the rushing wind.

> OLGA
> It's so fresh and beautiful. I
> love it.

> CLAUDE
> Get your head back in where it
> belongs. Remember you're
> pregnant.

Olga taps her stomach.

> OLGA
> How can I forget? How's baby
> Marianne?

> CLAUDE
> Fine. She's been sleeping all
> morning.

EXT. COUNTRY HOUSE - DAY

Claude's car pulls in, and Olga and Claude get out. JEROME,
Claude's nine year-old son, runs out to greet them,
followed closely by his Cocker Spaniel.

> JEROME
> Aunty Olga, come meet my new
> dog.

> OLGA
> What's his name?

> JEROME
> Luka.

> OLGA
> What a beautiful name. Did you
> choose it yourself?

> JEROME
> No. Mummy did.

 CLAUDE
 Come on in you guys. Let's have
 lunch.

INT. CLAUDE'S KITCHEN - DAY

The kitchen is very bright and has a rustic feel to it.
Jean-Pierre is preparing a large salad.

 JEAN-PIERRE
 Hey, the Olg is here.

 OLGA
 She's here and starving.

 CLAUDE
 You've been working on one lousy
 salad all morning, and it's not
 ready.

Jean-Pierre sets down the bowl on the table. They all sit
around a large wooden table.

 JEAN-PIERRE
 You call this lousy. This salad
 has every kind of green
 vegetable you can think of. And
 crushed pomegranates as
 dressing.

 OLGA
 Mmm. I have to eat for two
 people.

 JEAN-PIERRE
 So you're going to be a mother?

 OLGA
 Yep.

 JEAN-PIERRE
 Luc never called me last week to
 play tennis. I don't know what
 he's up to.

 OLGA
 I think he's avoiding all
 responsibilities. And he's
 avoiding us, so he's not
 reminded that he's avoiding the
 fact that he's going to be a
 father.

 CLAUDE
 What are you going to do?

 OLGA
 I'm going to leave him alone
 until he comes to his senses. Or
 until I am able to stop loving
 him.

Jerome is playing with the salad on his plate.

 JEROME
 Yukk. What are these?

 CLAUDE
 What are these, Jean-Pierre?

 JEAN-PIERRE
 Dandelions. They're good for
 you.

 CLAUDE
 You expect him to understand
 that?

 JEROME
 I want to go play. I don't like
 this green stuff.

 CLAUDE
 You had a big breakfast, so you
 can go play. He's been cooped up
 in an apartment all of his life.
 I'm giving him complete freedom
 for a few weeks to unwind.

EXT. BACKYARD - DAY

Olga and Claude are walking around. Jerome and Luka are
playing nearby. Olga carries her camera.

 OLGA
 Claude, it's so beautiful. You
 know, you're really lucky to be
 able to do this. Have a house, a
 family, a job and be happy.

 CLAUDE
 Sometimes I'm afraid I have too
 much.

> OLGA
> Don't be silly. How can you have
> too much? You have what most
> people dream of having.

> CLAUDE
> You too?

> OLGA
> In a way.

> JEROME
> Aunty Olga, will you take
> pictures of me and Luka now?

> OLGA
> Okay, how about holding her in
> your arms?

Olga takes photos. We hear a baby crying.

> CLAUDE
> That's Marianne. I'm going to go
> check on her.

Claude runs off.

> JEROME
> Did you have a dog when you were
> a kid?

> OLGA
> Uh-huh.

> JEROME
> What was his name?

> OLGA
> I can't remember.

> JEROME
> I'll never forget Luka's name as
> long as I live. What happened to
> your dog?

> OLGA
> He was killed.

> JEROME
> Did your parents get you another
> one?

> OLGA
> No, they never did. Come on,
> let's go see what Marianne is
> crying about.

INT. LIVING ROOM- NIGHT

Olga, Claude, and Jean-Pierre are sipping wine while
watching the news on television.

> TV NEWSMAN
> Two journalists were kidnapped
> this morning in the Lebanese
> capital, Beirut. They were both
> on their way to the refugee
> camps that surround the city,
> which has been the scene of
> violent fighting for the past
> three weeks. The number of
> hostages has risen to nine
> Americans and three Britons. In
> Managua, more protests …

> JEAN-PIERRE
> Beirut is hot again. Who do you
> have down there?

> CLAUDE
> No one. It's too dangerous to
> send any of the men there now
> with all the kidnappings. We're
> not covering the war in the
> refugee camps. We should.

The baby begins to cry.

> OLGA
> Claude, you've moved enough
> today. I'll check on Marianne.

INT. BABY'S ROOM - NIGHT

Olga walks in and lifts Marianne out of her crib and holds
her.

> OLGA
> Shhh-shhh. Marianne is so
> beautiful. She is a cutey. Why
> are you crying? Are you hungry?

Marianne stops crying and stares at Olga.

 OLGA
 That's better. Soon you'll have
 a new friend to play with. Are
 you two going to be best friends
 like your mums? Yes. Marianne is
 going to be so cute.

Claude walks in.

 CLAUDE
 Olga, phone call. It's the boss.

 OLGA
 What does he want?

 CLAUDE
 He didn't tell me. I think
 Beirut.

Claude takes Marianne, and Olga leaves.

INT. LIVING ROOM - NIGHT

Olga gets off the phone.

 OLGA
 He wants me in Beirut in two
 days.

 CLAUDE
 I figured.

 OLGA
 How did you know?

 CLAUDE
 I know how he thinks. He can't
 send any men; he trusts your
 work, so he sends you.

 OLGA
 He wants me to cover the refugee
 camp. He already arranged for a
 guide, and he wants me to spend
 the night inside the camp.

 CLAUDE
 God, that's exciting. Sometimes
 I miss those days. Did you
 accept?

> OLGA
> Yes. It'll be the last major
> trip before I have the baby.
> I'll take a year off and devote
> myself to diapers and baby food.

> JEAN-PIERRE
> Olga, it's a jungle in Beirut
> these days.

> OLGA
> I'm used to jungles.

> CLAUDE
> Are you sure you want to do it?
> I can make some calls; maybe
> someone else will accept to go.

> OLGA
> Claude, I'm going. Beirut is off
> limits to most foreigners. I'll
> be the only photographer around.
> Can you imagine what benefit
> that will be to my career?

> CLAUDE
> I'm just afraid for you, that's
> all.

> OLGA
> I'll be okay. Don't worry. We'll
> be okay.

EXT. RUINED BEIRUT STREETS - DAY

A car goes through deserted and ruined areas of the city.

EXT. REFUGEE CAMP - DAY

The car stops at the checkpoint.

INT. CAR - DAY

Olga sits in the front passenger seat. Her equipment and carry-on bags are on the back seat. A local AGENCY DRIVER is at the wheel.

> AGENCY DRIVER
> You get off here.

 OLGA
Here?

 AGENCY DRIVER
Yes. The boy should be here any
minute. He'll take you inside,
and you'll spend the night in
his house. Do you have enough
film?

 OLGA
Yes.

 AGENCY DRIVER
When you want me to pick you up
just tell one of the fighters.
They'll get the message to me.

EXT. REFUGEE CAMP - DAY

Olga gets out with her equipment. Three LEBANESE FIGHTERS
get closer in order to see what she is doing. They talk
amongst themselves.

 LEBANESE FIGHTER #1
 Where is Hani?

 LEBANESE FIGHTER #2
 Call Hani.

The third fighter runs off. Olga starts looking at the
other two. They stare back at her.

 LEBANESE FIGHTER #1
 Your guide will be here soon.

A young boy, HANI, aged about ten years old, comes running
over.

 LEBANESE FIGHTER #1
 Here he is. This is Hani, your
 guide. He will show you the best
 places to take photographs.

 OLGA
 This is my guide?

 LEBANESE FIGHTER #2
Yes.

 OLGA
But he's only a child.

 39

 LEBANESE FIGHTER #1
 He's old enough to take care of
 you and himself. He's my
 brother; I've trained him. You
 better get going before they
 start shelling.

Hani motions to Olga to follow him.

 HANI
 My name is Hani. What's yours?

 OLGA
 Olga.

 HANI
 That's hard. Can I call you Oli?

 OLGA
 If you want.

 HANI
 Come on Oli.

EXT. SHANTYTOWN STREET - DAY

Hani leads Olga through deserted narrow streets. We see a
dead horse, and we hear machine gun fire in the distance.

 OLGA
 Where did you learn your
 English?

 HANI
 At school. I also watch *Magnum*
 on TV.

 OLGA
 You get *Magnum* here?

 HANI
 Yes. My sister used to watch
 Dynasty too.

 OLGA
 Where is your house?

 HANI
 On the next street. My brother
 told me I should show you how we
 live. Is the world going to see
 our picture?

 OLGA
 I hope so.

 HANI
 What will they do when they see
 it?

 OLGA
 Hopefully they will do something
 that will make the war end soon.
 How old were you when the war
 started?

 HANI
 We've had war as long as I can
 remember.

Hani stops in front of a small house with a tin roof.

 OLGA
 Do you have any brothers or
 sisters?

 HANI
 I had a baby sister and an older
 sister.

 OLGA
 What happened to them?

 HANI
 They were coming back from the
 mountains with my mother and
 father, and a sniper aimed at my
 father. The car lost control and
 fell down into the valley. They
 all died.

 OLGA
 Do you live with your brother
 now?

 HANI
 Yes. Next year when I turn
 twelve they will send me to the
 military camp for training.

INT. HANI'S HOUSE - DAY

Olga studies the one large room filled with mattresses.

 HANI
 This is the safest room to sleep
 in at night when they are
 fighting. Before, we all used to
 sleep here. Now I'm alone. My
 brother is always fighting at
 night.

 OLGA
 Aren't you afraid?

 HANI
 Sometimes. But my brother tells
 me it is good training for me.

Olga reaches in her purse.

 OLGA
 Would you like a Mars bar?

 HANI
 Yes. My cousin Hamid got me one
 when he came back from America.

The sound of shells crashing is becoming louder.

 OLGA
 Have they started?

 HANI
 Yes. We can sleep now if you
 want.

 OLGA
 Yes, I want to take so many
 photos. Tomorrow we should start
 early.

Olga lies down on the mattress fully dressed. Hani lies on
a mattress on the other side of the room.

 HANI
 Oli?

 OLGA
 Yes, Hani?

 HANI
 Have you been to Disneyland?

 OLGA
 Yes, a long time ago.

42

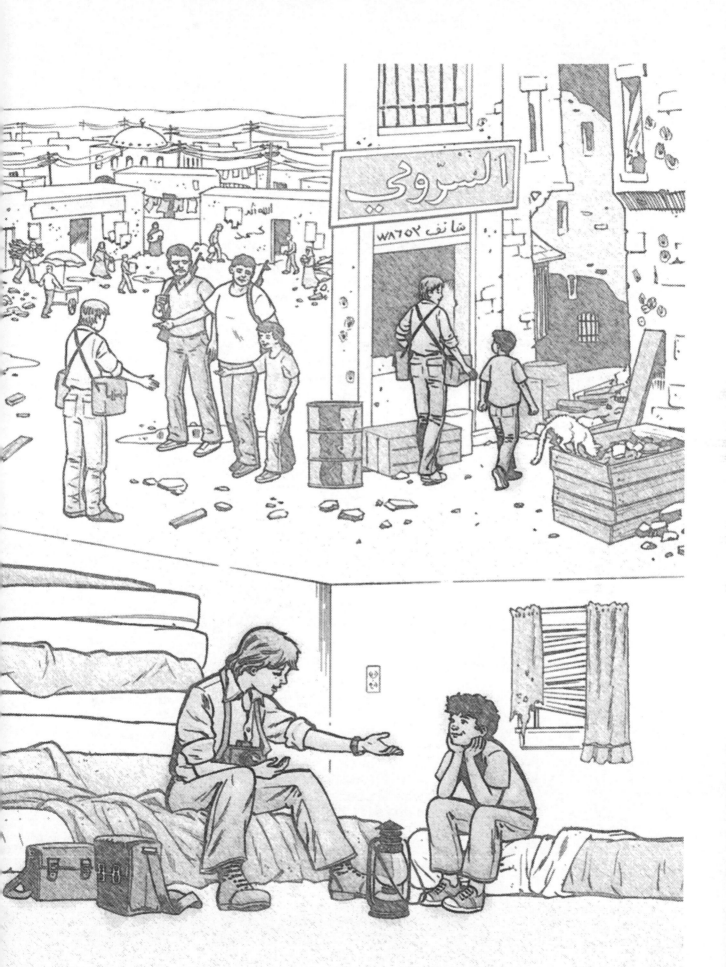

 HANI
 Is it really like magic?

Hani gets up and moves to a mattress closer to Olga.

 OLGA
 In a way.

 HANI
 I always dream that I'm going to
 Disneyland, but I wake up to the
 sounds of the bombs before I see
 it. My parents had promised to
 take me.

 OLGA
 Maybe one day you will go. Let's
 get some sleep now.

EXT. SHANTYTOWN STREET - DAY

Olga and Hani walk cautiously through the deserted street.
Olga stops to take a photograph every few seconds.

 HANI
 This way.

 OLGA
 To the school?

 HANI
 Yes.

EXT. SCHOOL YARD - DAY

An old burned-out building with a tin roof is the school.

 OLGA
 Is this where you study?

 HANI
 Yes, when there is no fighting.
 The kids sit here and the
 teacher here.

 OLGA
 Where do you play?

 HANI
 Come, I'll show you.

EXT. FIELD - DAY

A few boys Hani's age are building a tank from scrap metal
and unexploded grenades. They all greet Hani.

 HANI
 These are my friends.

 OLGA
 This is where you play?

 HANI
 Yes, we're practicing for our
 military training.

Olga begins to take photographs of the kids and the
surroundings. Suddenly we hear the loud sound of the
machine guns.

 OLGA
 Hani, take me closer, so I can
 take the photos.

 HANI
 Come this way.

Olga and Hani run towards the fighting. We begin to hear
the sounds of bombs exploding and shells crashing, the
noise getting closer ever minute.

 HANI
 They never fight in the
 mornings.

 OLGA
 Where is the best place to take
 photos?

Hani leads her up some stairs to a lookout. Olga takes a
few photographs.

 OLGA
 This is too far away. Can we get
 any closer?

 HANI
 I don't know where they are
 fighting; it's not the usual
 place.

 OLGA
 Just take me over there where
 these tanks are.

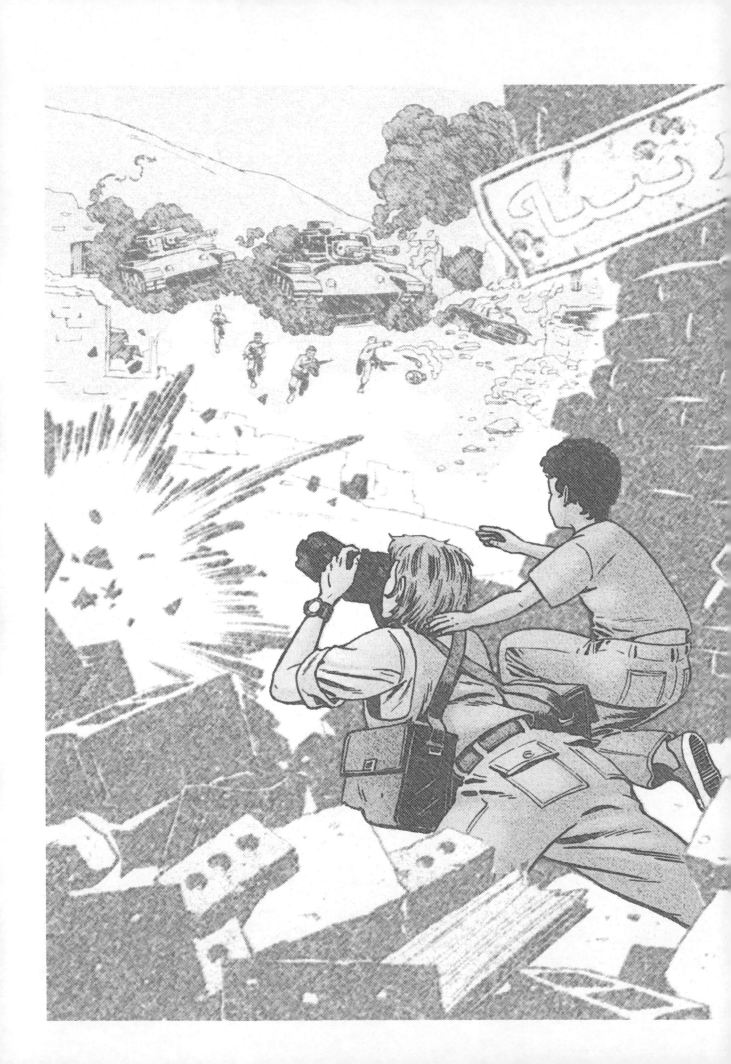

 HANI
 Are you sure?

 OLGA
 That's what I'm here for. I've
 seen worse.

 HANI
 Okay, come.

EXT. STREET - DAY

We can see the fighters firing rocket-propelled grenades. A
few tanks are also firing. Olga and Hani hide in an
alleyway. Olga takes photographs. She gets on her stomach
and moves slowly towards the main street using her elbows,
her camera on the ready.

 HANI
 Oli, don't go too close.

Suddenly a shell crashes nearby, sending dust and shrapnel
flying next to Olga and Hani.

 HANI
 Run, Oli.

 OLGA
 Just a minute; I have to take a
 few more.

Olga is still lying on the ground on her stomach.

 HANI
 (anxious voice)
 Oli, you don't know; they'll
 start using the big rockets
 next.

 OLGA
 Just one more minute, Hani.

A shell crashes right next to them. When the dust settles,
Olga is motionless. Hani drags her inside the alleyway, but
another shell crashes, and they are both enveloped in a
cloud of dust.

INT. REFUGE CAMP HOSPITAL - DAY

The ward is large, overcrowded, lined with beds. Lots of
nurses are running around. It's chaotic. Olga lies in one

of the beds close to a hallway. She slowly opens her eyes and clutches her stomach. She calls for a nurse — her tone is different. It is sharper, louder than normal.

> OLGA
> Nurse. Nurse.

NURSE LEILA comes over to Olga's bedside.

> NURSE LEILA
> Yes, Miss?

> OLGA
> What happened? Where am I?

> NURSE LEILA
> You were brought in two days ago in shock. I'll get you Doctor Hasan.

> OLGA
> What happened? Is my baby alright?

DOCTOR HASAN appears, running.

> DOCTOR HASAN
> I'm afraid you've lost the baby. You were very lucky; you only had a slight concussion. Nothing major. There's a shrapnel wound in your right leg. Everything should be healed in just a few days.

> OLGA
> My baby.

> DOCTOR HASAN
> You're going to be okay.

> OLGA
> No, I'm not. I was pregnant. Don't you understand? I lost my baby.

> DOCTOR HASAN
> You should thank God you weren't killed. The boy that was with you is in a coma. He lost his left arm.

 OLGA

Hani?

Olga turns away and closes her eyes. The Agency Driver that had dropped Olga off at the camp appears.

 AGENCY DRIVER
 Miss Olga, are you okay?

 OLGA
 I want to go home.

 AGENCY DRIVER
 I have plane reservations for
 you for the day after tomorrow.
 I'll come by and pick you up.

 OLGA
 Can you get my stuff from Hani's
 house? I left a few films that I
 shot there.

 AGENCY DRIVER
 It's not too safe to go there.

 OLGA
 I want my film. Find a way. I
 don't care how. Isn't the agency
 paying you enough?

 AGENCY DRIVER
 Yes, yes. I'll go right away.

The driver leaves. Olga looks around her and makes a face at all the chaos. She covers herself with the sheets.

A JOURNALIST comes by and stands by her bed.

 JOURNALIST
 Olga La Rochelle?

 OLGA
 Yes?

 JOURNALIST
 Do you mind if I interview you?

 OLGA
 What for?

 JOURNALIST
 I'd like to know what happened
 in the camp. You were a perfect
 target: a foreigner. They were
 out to get you. You are lucky
 you survived.

 OLGA
 What are you talking about? It
 was an accident.

 JOURNALIST
 A foreign photojournalist in the
 camp. Either they kidnap, or
 they kill.

 OLGA
 What's the use of pointing
 fingers? I need to rest. Would
 you please leave?

 JOURNALIST
 May I take a few photographs of
 your wounds?

 OLGA
 Would you get out?

 JOURNALIST
 Just one photo.

 OLGA
 OUT! Get out now! Nurse, nurse,
 can you throw this man out?

 JOURNALIST
 All right, I'm leaving. No need
 to get excited.

Olga covers herself with the sheets, making sure her ears
are covered.

INT. REFUGE CAMP HOSPITAL - NIGHT

Olga gets up from her bed.

 NURSE LEILA
 Where are you going, Miss?

 OLGA
 I need to walk. Where is the
 children's ward?

 NURSE LEILA
 Down the hall to your right.

Olga walks down the hall, limping slightly. She walks
slowly, heavily. We hear sounds of a baby crying. Olga
looks around. She walks from bed to bed, studying each
patient's face. She finally sees Hani, his eyes closed and
his left arm bandaged. She doesn't get closer to him but
quickly turns around and goes back to her bed, covering her
ears with her hands to block out the sound of the babies
crying from the next room.

EXT. PARIS CHARLES DE GAULLE AIRPORT - NIGHT

Plane lands.

INT. ARRIVALS GATE - NIGHT

A crowd of journalists wait for Olga who appears, walking
slowly. The journalists encircle her and begin to ask her
questions, all of them speaking at the same time.

INT. CLAUDE'S LIVING ROOM - NIGHT

Claude and Jean-Pierre sit watching the news on TV. It is
broadcasting live from the Arrivals Gate.

 TV NEWSMAN
 The API photojournalist who was
 wounded in the refugee camp last
 week arrived safely at Paris
 Charles de Gaulle Airport a few
 minutes ago. We are at the
 airport here live to ask Olga La
 Rochelle a few questions. Miss
 La Rochelle, were they aiming at
 you personally when you were
 wounded?

 OLGA
 No, it was an accident. I'm
 sorry I can't answer any
 questions; I'm too tired. Let me
 through please.

 TV NEWSMAN
 Will you go back to Beirut ever
 again?

> OLGA
> What good is it to go there and
> take photographs if nobody cares
> in the end?

> TV NEWSMAN
> So you will not return to Beirut
> ever again? Did you manage to
> take some good photographs at
> least?

> OLGA
> Is that all you bastards think
> about? Get out of my way.

Claude switches off the TV.

> CLAUDE
> I've never seen Olga talking
> like this before. I'm going to
> get her; she shouldn't sleep
> alone tonight. Will you prepare
> the guest room, honey, please?
> And feed Marianne?

> JEAN-PIERRE
> Sure. Just drive carefully.

INT. OLGA'S APARTMENT - NIGHT

Olga sits on her couch, rocking back and forth. She covers
her ears with her hands and shakes her head. The doorbell
rings repeatedly for quite a while before Olga hears it and
gets up to open the door.

> CLAUDE
> Olga, I'm so worried about you.

> OLGA
> I lost it. My baby.

Claude hugs her.

> CLAUDE
> It'll be all right. Come sleep
> at our place; I'm not going to
> let you sleep alone here.

> OLGA
> I can't stop these noises.

> CLAUDE
> What noises?

 OLGA
 Nothing.

INT. CLAUDE'S CAR - NIGHT

Olga stares out at the darkness as Claude drives.

 CLAUDE
 Your parents called to ask about
 you. They're passing through on
 their way to Greece next
 weekend. I told them you will
 see them.

 OLGA
 I don't feel like seeing anyone.
 I don't feel like talking to
 anyone.

INT. BABY'S ROOM - NIGHT

Baby Marianne is crying.

INT. GUEST ROOM - NIGHT

Olga is awakened by the sound of the baby crying. She moans
and covers her ears with her hands.

INT. CLAUDE'S KITCHEN - DAY

Claude is making breakfast. Olga shuffles in, dazed.

 CLAUDE
 Are you okay?

 OLGA
 Fine.

 CLAUDE
 You didn't tell me much
 yesterday. Can we talk?

 OLGA
 I don't feel like talking.

 CLAUDE
 Do you want me to give you Dr
 Grummons's phone number?

 OLGA
 What for?

 CLAUDE
 You've obviously been through a
 hell of a lot during the past
 week; maybe talking to him will
 help.

 OLGA
 Do you think so?

 CLAUDE
 Let me call and make an
 appointment for you. Try it
 once, see how you feel.

Claude reaches for the phone. Olga gets up.

EXT. BACKYARD - DAY

Olga walks in the garden, not aware of her surroundings or
of Jerome and Luka who come running to greet her.

 JEROME
 Hi Aunty Olga.

She pushes Luka away.

 JEROME
 Luka wants to say hi to you.

Olga continues to walk, lost in a different world.

 JEROME
 Will you come to the woods with
 us for a walk? Please Aunty,
 come on.

 OLGA
 (yelling)
 Leave me alone, Jerome. Stop
 nagging.

 JEROME
 Luka, come on.

Claud has witnessed the scene. She stands shaking her
head, looking at Olga.

INT. CLAUDE'S CAR - DAY

Claude drives. Olga stares out of the window.

> CLAUDE
> I'm sorry I can't drive you all
> the way into the city.

> OLGA
> It's okay.

> CLAUDE
> Are you going to call Luc?

> OLGA
> I have no emotions towards that
> man any more.

> CLAUDE
> Are you sure you don't want to
> come back and sleep at our house
> tonight?

> OLGA
> I'll be okay, Claude.

> CLAUDE
> I should be in the office next
> week; we'll get together.

> OLGA
> I want to go and talk with the
> boss. I'll stop by to see you.

EXT. TRAIN STATION - DAY

Olga is just about to disappear inside the train. Claude
waves.

> CLAUDE
> Don't forget your appointment
> with Dr Grummons this afternoon.

> OLGA
> I won't.

> CLAUDE
> And your parents will be in town
> on Sunday at the George V. Call
> me. Bye.

The train pulls out.

INT. TRAIN - DAY

Olga sits in a compartment by herself and stares out of the
window. A mother carrying a baby comes in and sits down.
Olga turns to look at them. The woman smiles. Olga looks
away. The baby begins to cry. Olga grimaces. The baby's
crying gets louder. Olga covers her ears with her hands and
gets up. She finds a seat away from the sound and sits
down.

EXT. PARK - DAY

Olga walks slowly, unaware of anything around her.

INT. DOCTOR GRUMMON'S OFFICE - DAY

DOCTOR GRUMMON, a middle-aged man with huge eyeglasses,
sits behind his desk. Olga sits on the couch.

 DOCTOR GRUMMON
 You may lie down if you wish.

 OLGA
 I'm fine, thank you.

 DOCTOR GRUMMON
 Claude was very worried about
 you when she called me. You've
 been through a lot during the
 past week. It will take you a
 while to be able to talk about
 what happened. You're in a state
 of shock. I suggest you come and
 see me two or even three times a
 week. You should also take one
 of these pills after every meal;
 you have to take them regularly
 for them to be effective. I'm
 sure you will soon be feeling
 better.

 OLGA
 Will the noises stop?

 DOCTOR GRUMMON
 It'll take time. Be patient. My
 secretary will make next week's
 appointments for you. Have a
 good weekend.

Grummon leads Olga to his SECRETARY and leaves.

 GRUMMON'S SECRETARY
Which days would be best for
you?

 OLGA
I won't be coming back. Thank
you.

 GRUMMON'S SECRETARY
But does the doctor know?

 OLGA
You can tell him.

Olga walks out. She slams the door behind her.

EXT. PARK - DAY

Olga walks by the river, still holding the prescription
that the doctor gave her. She tears it up into small pieces
and throws it in the river.

EXT. OFFICE BUILDING - DAY

Olga walks in.

INT. OFFICE - DAY

Olga is greeted by the office staff. She goes up to the
BOSS'S SECRETARY

 BOSS'S SECRETARY
 You can go right in; he's
 expecting you.

INT. BOSS'S OFFICE - DAY

 BOSS
 Hello, Olga.

 OLGA
 Hi.

 BOSS
 I'm sorry to hear about your
 little accident.

 OLGA
 I have to go back to Beirut.

 BOSS
 What?

 OLGA
 I have some unfinished business.

 BOSS
 Olga, it's getting too
 dangerous. The state department
 has even declared the place off
 limits.

 OLGA
 I lost my best photographs.

 BOSS
 Don't worry about that. The
 important thing is your health.

 OLGA
 Will you call me if something
 changes in the situation?

 BOSS
 I sure will, but I doubt that
 will be soon.

 OLGA
 Thank you.

 BOSS
 Goodbye, Olga.

INT. CLAUDE'S OFFICE - DAY

Olga opens the door. The office is empty.

INT. OLGA'S APARTMENT - NIGHT

Olga is on the phone to Claude.

 OLGA
 … and he goes "you may lie down
 now" as if I'm a psycho or
 something. I don't need a
 shrink, Claude.

INTERCUT WITH:

INT. CLAUDE'S HOUSE - NIGHT

> CLAUDE
> Try seeing him just one more
> time, Olga. I'm sure he can help
> you.

> OLGA
> No, I'm fine, Claude. Really.
> I'm going to see my mother
> tomorrow night. I have no
> energy, but at least I have
> something to do.

> CLAUDE
> You can always come up here.
> Remember that, Olga. My home is
> your home. Always.

> OLGA
> Thanks, Claude.

> CLAUDE
> Didn't your dad come with your
> mum?

> OLGA
> No. He told my mother to go
> alone with her friends. He just
> wants to stay at home and write.
> He's probably having an affair
> with the neighbour's wife or
> something.

> CLAUDE
> He's seventy years old.

> OLGA
> That doesn't mean anything to my
> father.

> CLAUDE
> Listen, Marianne is crying. I
> have to go.

> OLGA
> Claude?

> CLAUDE
> Yes, Olga?

 OLGA
 I need to work again. When you
 get back to the office, will you
 find me something to do? A
 project in town here. Anything.
 I need to do something.

 CLAUDE
 I'll try, Olga. Take care.

She hangs up.

INT. APARTMENT HALLWAY - NIGHT

Olga knocks on Claire's door. Her husband, LOUIS — a big,
bearded man — opens the door.

 LOUIS
 Yes?

 OLGA
 Is Claire here?

 LOUIS
 No.

 OLGA
 Where is she?

 LOUIS
 She's resting.

 OLGA
 I need to see her.

 LOUIS
 No, you can't. Leave her alone.

He slams the door.

EXT. GEORGE V HOTEL - NIGHT

Olga walks in. She's dressed in jeans and sweatshirt, her
hair's a mess.

INT. GEORGE V RESTAURANT - NIGHT

People stare as Olga walks in. It is a very fancy
restaurant, and everyone is well dressed. Olga sees her
MOTHER and walks over to the table.

 MOTHER
Olga, I missed you dear. Why are
you dressed like this?

 OLGA
Mother, I told you I'm in no
mood to go out anywhere. I could
have cooked you something at
home.

 MOTHER
I like this place. You could at
least have fixed your hair. Why
do you do these things, Olga? To
spite me perhaps?

 OLGA
Listen, Mother, you're on your
way to Greece to take a cruise.
You're staying in the most
expensive, yet tasteless, hotels
in Paris. You want to have food
that looks like a Cézanne
painting … These are your
concerns in life. I have my own
problems to worry about, and
right now I don't feel like
looking good because I feel
awful.

Olga's mother doesn't listen to half of what Olga says.

 MOTHER
How's your work?

 OLGA
Fine. Just fine.

 MOTHER
When are you going to come out
to Long Island and see your
father?

 OLGA
Soon, Mother.

 MOTHER
Can we set a date?

 OLGA
No, I've got more important
things on my mind right now.

 MOTHER
 What could be more important
 than making your father happy by
 being with him on his seventieth
 birthday?

 OLGA
 He doesn't need us, Mother. He
 never did. He never needed
 anyone.

 MOTHER
 Still, would you try coming on
 his birthday?

 OLGA
 I'll try.

Two well-dressed older women (JUNE & HOLLY) wave to Olga's
mother.

 JUNE
 Gail, there you are.

 MOTHER
 Where were you? I left you
 messages at the reception.

 HOLLY
 We went shopping, of course.

 MOTHER
 Well, sit down. Join us for
 dinner. This is my daughter
 Olga.

 JUNE
 Oh, nice to meet you.

 HOLLY
 Who would have imagined that you
 have such an older daughter? No
 offence to you, dear, it's just
 that Gail looks so young.

 MOTHER
 How about some champagne?
 Waiter. A bottle of Dom
 Pérignon. Make sure it's well
 chilled.

 OLGA
 Mother, this is Paris. You don't
 have to tell the waiter to get
 the champagne chilled.

Olga's mother ignores her.

 MOTHER
 Well, let's see what's on the
 menu tonight. What would you
 like to eat, Olga?

 OLGA
 Nothing. I'm not hungry.

 MOTHER
 Come on, you must have
 something.

 OLGA
 I'm fine, Mother, really.

 HOLLY
 So, Olga, how long have you
 lived in Paris?

 OLGA
 Fourteen years.

 HOLLY
 My, it must be wonderful living
 in such a beautiful city.

 MOTHER
 Olga is a well-known
 photojournalist. Tell them about
 your work, Olga.

 OLGA
 I really don't feel like
 talking.

 MOTHER
 Come on, we are all here to have
 a good time.

The waiter brings the champagne.

 MOTHER
 Cheers everyone.

The two women begin chatting among themselves.

 OLGA
Mother, I thought we were going
to have a quiet dinner.

 MOTHER
We are, aren't we?

 OLGA
No, I mean just the two of us. I
have something to tell you.

 MOTHER
Tell me, honey; June and Holly
are my best friends.

The two women stop talking and smile at Olga.

 OLGA
I was pregnant when I was
wounded in Beirut. I lost the
baby.

Olga's mother bursts out laughing.

 MOTHER
Ahhh, that's a good one, Olga.
You got a free abortion.

 OLGA
It's not funny; I was going to
keep it, Mother.

 MOTHER
Don't be ridiculous, Olga. How
can you raise a child all by
yourself when you're travelling
around the world half the time?

 OLGA
I could have managed.

 MOTHER
A child needs time and lots of
care.

 OLGA
How come you didn't give me
that? That's not the point. I
lost my baby, and here you are
drinking and wanting me to be
merry and happy.

 MOTHER
I miscarried three times before
I had you. It happens, Olga.

 OLGA
But don't you see? It was my
last chance. I'm forty-two years
old. Time is running out for me.

 MOTHER
Drink, and forget.

 OLGA
I don't want to be like you. I
don't want to forget. I lost my
baby.

 MOTHER
Well, instead of brooding over
it, why don't you go and try to
make yourself another baby?

 OLGA
It's that simple for you, huh?
I'm leaving, Mother. Don't
bother calling me; I won't
answer the phone. I can't handle
you at this stage of my life.

Olga gets up and walks away.

EXT. PARIS STREET - NIGHT

Olga walks in the lively streets of Paris, covering her
ears with her hands. She sees a crowd of people hanging
around a bar. She goes in.

INT. BAR - NIGHT

Olga pushes her way inside. She sits at the bar.

 BARMAN
 Yes?

 OLGA
Double Finlandia on the rocks.

Olga sees a MAN who resembles Luc; he has the same large
green eyes. She stares at him across the bar. His
girlfriend notices Olga staring and whispers something in
his ear. The man walks a few steps towards Olga. Olga gulps
down her drink.

> MAN
> Is anything wrong?

> OLGA
> No. Why?

> MAN
> You've been staring at me.
> You're making my girlfriend
> nervous.

> OLGA
> I like your eyes. Do you think I
> can have your baby?

> MAN
> I think you're crazy.

He walks off.

JEFFROY, a younger man, about twenty-six years old, sitting
not too far from Olga, has witnessed the whole scene. He
gets closer to Olga and whispers in her ear.

> JEFFROY
> I like making babies.

> OLGA
> Really? Why are you telling me?

> JEFFROY
> I heard what you told the other
> man.

> OLGA
> Oh.

> JEFFROY
> Do you want to come to my place?

> OLGA
> Is it that simple?

> JEFFROY
> What?

> OLGA
> Nothing. Okay, let's go.

INT. JEFFROY'S BEDROOM - NIGHT

The bed is small. It creaks when Olga sits down on it.
Jeffroy takes his clothes off quickly.

> JEFFROY.
> Do you really want to have a
> child?

> OLGA
> Yes.

> JEFFROY
> Why?

> OLGA
> Why don't you shut up, and do
> what you have to do.

The man takes Olga's jeans off. He kisses her, and she doesn't react. She grimaces as he goes in. His breathing becomes heavy. Olga covers her ears with her hands and moans.

> OLGA
> Stop. Stop. Leave me alone.

> JEFFROY
> I can't stop now.

> OLGA
> Yes you can.

She shoves him off her, picks up her jeans and shoes and runs to the door.

> JEFFROY
> Come back here.

INT. APARTMENT STAIRS - NIGHT

Jeffroy comes out, running after Olga.

> JEFFROY
> You're crazy, you hear me,
> crazy.

INT. OLGA'S APARTMENT - NIGHT

Olga lets herself in. Her hair is a mess, her face blank and expressionless. She stoops as she walks across the room to pour herself a glass of wine. She switches on the stereo, playing her favourite Barbara album. Barbara sings "THE PAIN OF LIVING". Olga reaches for her portfolio and flips through the photographs that she took of Hani and stares at them. She begins to cry loudly.

INT. CLAUDE'S OFFICE - DAY

Olga and Claude are drinking coffee.

> OLGA
> I really need to work, I'm going
> crazy with nothing to do. I used
> to love these days when I would
> be free, waiting for the next
> assignment. Now I can't face the
> emptiness.

> CLAUDE
> Are you seeing a doctor?

> OLGA
> No, Claude. I told you I'm not
> going to see any doctor.

> CLAUDE
> You know, I was reading
> somewhere the other day that
> mangoes have an anti-depressant
> substance in them.

> OLGA
> Mangoes — as in fruit?

> CLAUDE
> Uh-huh. I'm going to try it the
> next time I feel low — see if it
> works.

> OLGA
> So when do you think I'll get an
> assignment?

> CLAUDE
> Don't you think you need to
> rest … take some time off …
> before you begin working again?

> OLGA
> No, I need to start working.
> Will you call me if something
> comes up? Even a small thing
> around the city.

> CLAUDE
> I'll try.

 OLGA
And if you have the chance to
remind the boss that I still
want to go to Beirut.

 CLAUDE
Why do you want to go back
there?

 OLGA
I need to see how Hani is doing.

 CLAUDE
Is he the boy that was injured
with you?

 OLGA
Yes. He needs special medical
care. I wish I could get him a
good hospital in Paris.

 CLAUDE
You really like the kid, don't
you?

 OLGA
He lost his left arm because of
me. Isn't there anything we can
do for him from here?

 CLAUDE
I'll see what I can do. I'll try
calling our contact in Beirut.

 OLGA
Okay. Thank you, Claude.

 CLAUDE
See you, Olga.

INT. APARTMENT BUILDING - DAY

The concierge greets Olga as she walks in.

 CONCIERGE
Good afternoon, Miss Olga.

 OLGA
Any messages for me?

 CONCIERGE
No, Miss Olga.

INT. APARTMENT HALLWAY - DAY

Olga knocks on Claire's door. The husband, Louis, opens.

> LOUIS
> Yes? Oh, you again. Claire's not
> here.

> OLGA
> Where is she?

> LOUIS
> I don't know.

> OLGA
> What do you mean you don't know?

> LOUIS
> She left me two days ago. She
> said she is never coming back.

> OLGA
> What did you do to her?

> LOUIS
> It is none of your business.

> OLGA
> You beat her again. You bastard.

> LOUIS
> Watch your language, lady.

> OLGA
> I hope you never get to see your
> child. You don't deserve to be a
> father, you animal.

> LOUIS
> She lost the baby.

> OLGA
> What? Oh, I could kill you.

> LOUIS
> You're crazy, get out of here.

> OLGA
> You beat her till she lost the
> child. I could really kill you.

He slams the door in her face. She stands there shaking for
a few seconds, and then she walks away.

INT. OLGA'S APARTMENT - DAY

Olga listens to Barbara sing 'BLACK SUN'. She sits in a
foetal position next to the stereo. She stops it and
listens again to the part she likes most.

> BARBARA
> (on stereo)
> *But a child is dead,*
> *somewhere out there,*
> *a child is dead,*
> *and the sun turned black.*
> *But a child is dead,*
> *and the sun turned black,*
> *and despair sets in,*
> *despair sets in.*

She listens to that part one more time.

The phone rings. Olga picks it up.

> OLGA
> Hello?

INTERCUT WITH:

INT.CLAUDE'S OFFICE - DAY

> CLAUDE
> Olga, it's Claude. There is a
> fire two blocks from your place
> on Rue de Passy. There is a
> family trapped inside. We need
> photos, quick.

> OLGA
> I'm on my way.

> CLAUDE
> You sure you're okay?

> OLGA
> Yes. I'm leaving right away.

Olga hangs up, grabs her equipment and rushes out.

EXT. BURNING HOUSE - DAY

A group of onlookers stand as firefighters are just
beginning to arrive. There are no journalists or TV crews
in sight. Olga arrives, running. She talks to one of the
SPECTATORS.

 OLGA
 Are the people still inside?

 SPECTATOR
 Yes. Look on the balcony up
 there: a small child.

Olga runs closer to get a better look, waving her press
card, so the firemen let her through. The child is crying
and screaming for help. The firefighters are preparing to
rescue him, but the flames are getting closer to him by the
second. His screaming gets louder. Olga hears the screams.
She freezes. She cannot take a single photograph. She drops
the camera and covers her ears with her hands. She sits
down on the pavement, her head tucked between her knees.

EXT. OPEN AIR MARKET - DAY

Olga walks slowly, heavily. She buys some fruit from an OLD
MAN.

 OLGA
 Do you have any mangoes?

 OLD MAN
 Yes, but they are very
 expensive.

 OLGA
 It's okay. I'll take six.

 OLD MAN
 That'll be 165 francs.

 OLGA
 That is expensive.

 OLD MAN
 They're flown from Haiti.

 OLGA
 Okay, thanks.

INT. OLGA'S APARTMENT - DAY

Olga's mouth is all yellow. Mango skins and stones lie
piled on a plate in front of her. She eats the last one
savagely, wiping her mouth with her sleeve.

INT. OLGA'S APARTMENT - NIGHT

Olga lies on the couch in her living room. Used coffee cups on the table. Dead flowers in the vase. She is on the phone.

 OLGA
 I don't know what happened; I
 just dropped the camera. I can't
 take any more photos.

INTERCUT WITH:

INT. CLAUDE'S LIVING ROOM — NIGHT

 CLAUDE
 The boss is angry; he wanted a
 picture of that boy on the
 balcony before he died. UPI got
 it. He told me not to give you
 any more assignments until you
 feel better.

 OLGA
 But I'm fine. I tried eating
 mangoes; I ate six of them. I
 don't feel any happier.

 CLAUDE
 Olga, please go see Dr Grummons.
 You need some help to get
 through this bad period in your
 life.

 OLGA
 Every time I talk to you, you
 urge me to go see that shrink.
 You like to see me crazy? What
 kind of friend are you?

 CLAUDE
 Why don't you call me back when
 you've calmed down?

 OLGA
 No, I don't want to talk to you
 again.

 CLAUDE
 I have something to tell you.

 OLGA
 What?

 CLAUDE
 The boss sent Francois to Beirut
 today.

 OLGA
 What? I'm sure it was your fault
 he didn't send me. You've been
 telling everyone I need a
 shrink. Don't call me again. All
 you care about is your stupid
 country life. Leave me alone.

Olga hangs up.

EXT. STREET - NIGHT

Olga walks quickly, almost running.

EXT. OFFICE BUILDING - NIGHT

Olga walks in.

INT. OFFICE - NIGHT

Olga goes straight to the boss's secretary, not bothering
to greet anyone.

 OLGA
 I need to see the boss.

 BOSS'S SECRETARY
 Olga, I think he's very busy
 right now.

 OLGA
 Tell him it's very very
 important.

Boss's secretary picks up the phone.

 BOSS'S SECRETARY
 Miss La Rochelle is here to see
 you. Yes, she says it's
 important. Okay.

She looks up at Olga.

> BOSS'S SECRETARY
> Uhh, he's busy on the line with
> New York, and then he has a
> plane to catch in an hour to
> London. Maybe you can come back
> Monday morning?

> OLGA
> No, this can't wait.

Olga storms in to the boss's office.

INT. BOSS'S OFFICE - NIGHT

The boss looks up, surprised.

> OLGA
> I need to talk now.

> BOSS
> I'm busy with New York.

Olga grabs the phone out of his hand and throws it to the
floor.

> BOSS
> What's the meaning of all this?

> OLGA
> You sent Francois to Beirut?

> BOSS
> Yes.

> OLGA
> After you promised to send me. I
> need to go there. Hani is dying.
> I want to be with him.

> BOSS
> Your personal life cannot be
> mixed with work, Olga.

> OLGA
> Personal life? I have no life.
> My work took away my baby. My
> work put a friend of mine in a
> coma. Hani is dying, and it's
> all for a stinking photograph
> that people will like, but will
> it change anything? No, because
> the wars just go on and on, and
> we keep taking photographs.

 BOSS
 What is it that you want me to
 do?

 OLGA
 I want you to get Hani out of
 Beirut to a good hospital here
 where he can be taken care of
 properly. He lost his arm damn
 it.

 BOSS
 We are not responsible for
 guides.

 OLGA
 But he is a child.

 BOSS
 He's still a guide. I can't do
 anything for you, Olga. I have
 to ask you to leave. We won't be
 giving you any more assignments.

 OLGA
 Then you're going to pay for
 this, you bastard.

She picks up the ashtray and throws it at him. He ducks and
picks up the phone.

 BOSS
 Get me security, now.

 OLGA
 You've just taken all I've lived
 for, you bastard.

The security guards come in.

 BOSS
 Take her outside please.

 OLGA
 I'm going; leave me alone.

Claude watches as the two guards lead Olga outside. She
sits down on the desk and wipes away a few tears. She
addresses a colleague.

 CLAUDE
 Poor Olga. I've done all I can.
 I don't know what to do anymore.

EXT. STREET - NIGHT

Olga walks slowly, her hands covering her ears. She goes
into a pharmacy.

INT. APARTMENT BUILDING - NIGHT

The concierge comes out.

> CONCIERGE
> Bonsoir, Miss Olga. Mr Luc came
> by to see you. He told me he'll
> be back to see you later on
> tonight.

> OLGA
> Thank you, Madame.

> CONCIERGE
> Good night, Miss Olga.

INT. OLGA'S LIVING ROOM - NIGHT

Olga sits, rocking back and forth, on her couch. She gets
up and collects together all of her photos that are hung on
the walls and in her portfolio. She puts them on the pile
on the floor and begins tearing them up, putting the pieces
in a big black garbage bag. She puts on her Barbara album.

INT. OLGA'S KITCHEN - NIGHT

Olga opens a bottle of wine. She gets out a package of
pills.

INT. OLGA'S LIVING ROOM - NIGHT

Olga writes a note: "Inside this bag you will find all that
I have lived for. It was not worth the pain." She takes a
handful of pills and gulps them down with a long drink of
wine. She turns up the stereo and takes her time to find
the song she's looking for: 'THE DEATH'.

> BARBARA
> (on stereo)
> *Who is that woman walking in the*
> *street?*
> *Who is she?*

Olga lies down on her couch in the foetus position and
covers her ears with her hands.

> BARBARA
> (on stereo)
> *Who is that woman?*
> *She is beautiful.*

Olga moans.

> BARBARA
> (on stereo)
> *That woman is death.*
> *She is death.*
> *Death.*
> *Death.*

EXT. STREETS OF PARIS - NIGHT

We hear the loud siren of an ambulance, and we see its
lights flashing as it races through the streets of Paris.
The city is very quiet and looks beautiful as the first
light of dawn breaks through. Nothing moves except the
ambulance, which slowly fades away from our view.

EXT. MONASTERY OVERLOOKING THE SEA - DAY

We see a beautiful white building surrounded by gardens,
and we see some people in robes and pyjamas. We discover
that it is a mental hospital. We hear the voice of DOCTOR
CLOT.

> DOCTOR CLOT
> (V.O.)
> Do you really want to die?

INT. DOCTOR CLOT'S OFFICE - DAY

A bright room. We see Olga, her back to us, sitting in a
large armchair, staring out at the sea. We now also see
Doctor Clot.

> DOCTOR CLOT
> Talk to me, Olga. Do you really
> want to die? You've been here
> for three months, and all you do
> is sit and stare out at the sea.
> You must be thinking about
> something. What is it?

> OLGA
> I think I killed someone.

 DOCTOR CLOT
How?

 OLGA
I made a boy take me closer to
the fighting. A shell crashed
nearby, and he was in a coma.
He's probably dead by now.

 DOCTOR CLOT
Were you friends with this boy?

 OLGA
He was the only friend I had.

 DOCTOR CLOT
Talk to me, Olga. What else
bothers you?

 OLGA
I have nothing to live for. Are
you sure you want to hear this?
You've probably heard it a
million times from a million
different people.

 DOCTOR CLOT
I'm here to hear you, Olga.

 OLGA
All my life I took photographs.
Photographs of starving people
in Africa, or dying people in
the Middle East and South
America. I've given my life to
let the world know the truth.
But do they care? Do they really
want to know? I think they
prefer not to see. You tell me,
do they care?

 DOCTOR CLOT
I'm sure they care, Olga.

 OLGA
Oh no they don't. If they do,
then why don't these wars stop?
I went to Ethiopia in 1973 to
cover the famine, and I went
back last year again. The people
just got hungrier. And there
were more photographers in one
place than I have ever seen. We
just let all those people
starve.

 DOCTOR CLOT
You can't worry about the whole
world.

 OLGA
I have to capture the suffering
of the world. How can I not
worry?

 DOCTOR CLOT
Now you have to worry about
getting better.

 OLGA
I prefer to die.

 DOCTOR CLOT
And give up all that you have
worked for?

 OLGA
I killed Hani, and I killed my
baby.

 DOCTOR CLOT
You didn't kill anyone, Olga.
You don't know if Hani is dead,
and you can't blame yourself for
a miscarriage.

 OLGA
Would you let me go to the
office one day? Maybe Claude
knows something about Hani.

 DOCTOR CLOT
I can't let you go anywhere
until you promise me that you
want to live, that you have no
intention of ending your life.
I'll call Claude and try to have
her find information for you.

> OLGA
> Can I go now?

> DOCTOR CLOT
> Yes. One more thing: Luc Brie
> has been calling to ask about
> you.

> OLGA
> I don't want to see him ever.
> Tell him not to call.

> DOCTOR CLOT
> And your mother has been
> calling.

> OLGA
> Tell her I'll call her when I
> feel better. Not now. Who else
> asks about me?

> DOCTOR CLOT
> Claude does every other day.
> Would you like to see her?

> OLGA
> Maybe.

EXT. HOSPITAL GARDENS - DAY

Olga sits on a bench looking out towards the sea. Claude comes up from behind her and touches her shoulder.

> CLAUDE
> Olga, I missed you.

Olga doesn't move.

> CLAUDE
> Everyone misses you. Jerome is
> always asking about you. Are you
> still mad at me, Olga?

Olga reaches out and holds Claude's hand.

> OLGA
> You have news about Hani?

 CLAUDE
 He's out of the coma. He even
 went back to school. A UPI
 journalist interviewed him last
 week. Hani asked about you. He
 still remembers you, Olga.

 OLGA
 Are you sure you're not lying to
 me to make me feel better?

 CLAUDE
 I never lied to you, Olga.
 Here's a photo that UPI guytook.

Olga looks at the photo of Hani, his arm all bandaged up,
smiling his big smile.

 OLGA
 I'm tired, Claude. Will you come
 see me another time?

 CLAUDE
 Sure, Olga. Take care.

Claude kisses her and leaves. Olga holds the photo and
cries quietly.

 HANI
 (V.O.)
 Have you been to Disneyland?
 Is it really like magic?
 I always dream that I am going
 to Disneyland, but I wake up to
 the sound of the bombs before I
 see it.

EXT. BEACH - DAY

Olga walks on the sand, deep in thought.

EXT. FIELD - DAY

Olga sits under a tree, still holding Hani's photograph.

INT. OLGA'S HOSPITAL ROOM - DAY

Olga packs her belongings slowly.

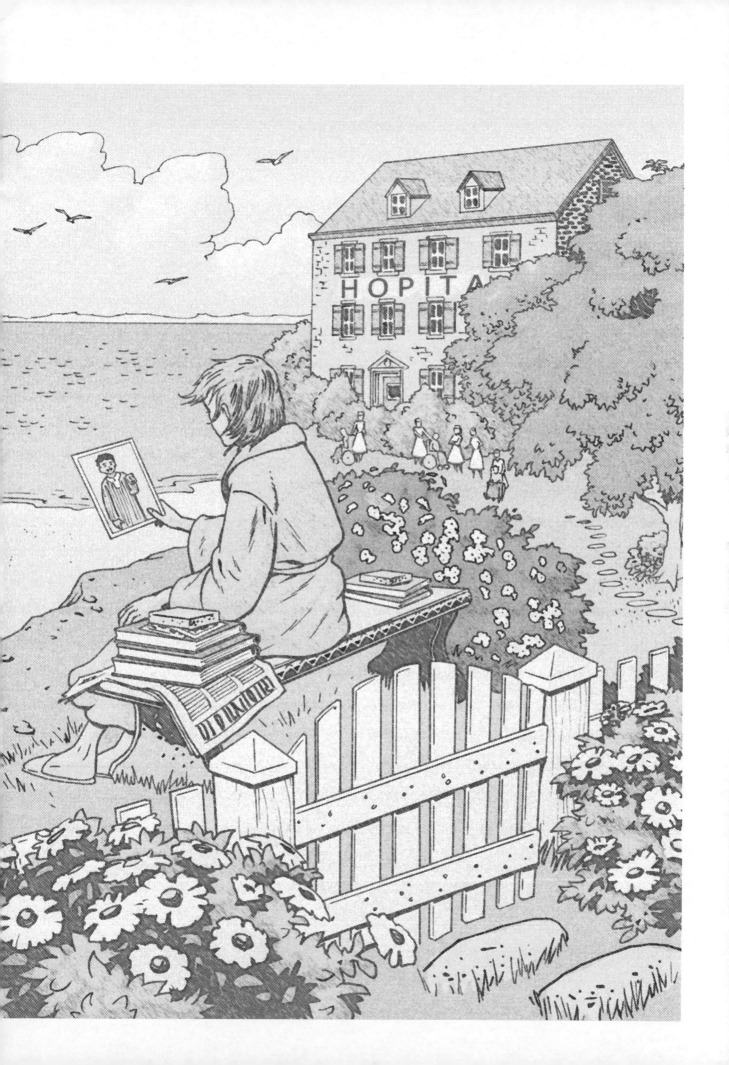

INT. DOCTOR CLOT'S OFFICE - DAY

Olga is dressed up, holding her bag.

> OLGA
> I need to leave for a while. You
> can discharge me today; I don't
> want to die right away.

> DOCTOR CLOT
> Where are you going?

> OLGA
> I'm going to take Hani to
> Disneyland. I have to hurry
> before he is sent to military
> training.

> DOCTOR CLOT
> Olga, you can leave right now.
> Call me if you need something.
> This place isn't for you; you
> are far too conscious to be
> stuck in a place like this.

> OLGA
> Thank you, Doc.

EXT. HOSPITAL PARKING LOT - DAY

Olga sits on her bag on the small, quiet road that leads to
the hospital. She is waiting for someone. A car slowly
approaches. Claude is driving. Jerome and Luka are in the
back seat. Olga kisses everyone and gets in. The car moves
away slowly.

INT. CLAUDE'S CAR - DAY

Olga is looking out of the window again but smiling this
time.

> OLGA
> You know, Claude, I think we
> should stop somewhere and buy
> ourselves a crate of mangoes. I
> think it'll work out even if I
> eat one of them today.

Claude laughs. Luka barks.

> CLAUDE
> Oh, Olga, you are a gem.

EXT. COUNTRY ROAD - DAY

It is autumn, and the road is lined with trees of different colours. Olga sticks her head out of the window of the car.

> OLGA
> It's so beautiful. I love the
> fall.

She smiles and takes a deep breath.

> OLGA
> It's out of this world.

<u>THE END</u>

The Lebanese Civil War 1975 - 1991

It is estimated that more than 100,000 were killed, and another 100,000 left handicapped, during Lebanon's 16 year war. Up to one- fifth of the pre war resident population, or about 900,000 people were displaced from their homes, of whom perhaps a quarter of a million emigrated permanently. The last of the western hostages taken during the mid- 1980s were released in May 1992.

www.globalsecurity.org/war/Lebanon

Profits from this book go to the Haas Mroue Memorial Trust. The TRUST is created to honour Haas's wishes to sponsor deserving students of Creative Writing.

For further information and/or donations see Haas Mroue Memorial Site at www.haasmroue.net.

Printed in the United States
By Bookmasters